With bunches of hugs

to _____

from _____

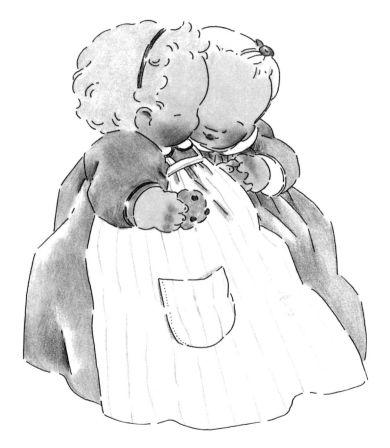

Two Little Ladies

a book about friends

illustrated by
michel bernstein

Andrews and McMeel
A Universal Press Syndicate Company
Kansas City

ISBN: 0-8362-4715-9

Two Little Ladies

a book about friends

Two little ladies,
you and me...

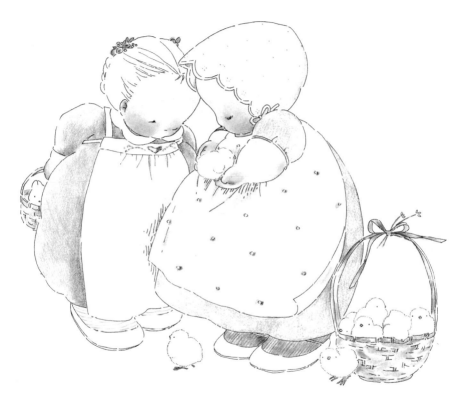

*. . . all dressed up
and out for tea !*

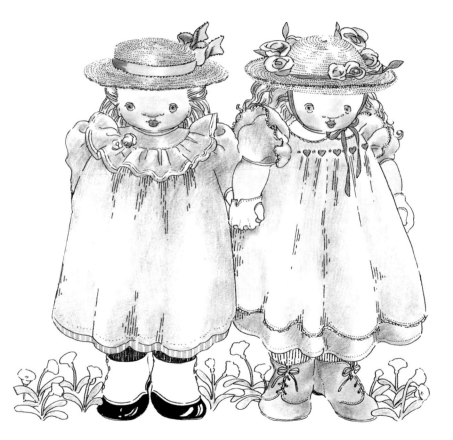

Telling a secret.
(One lump or two?)

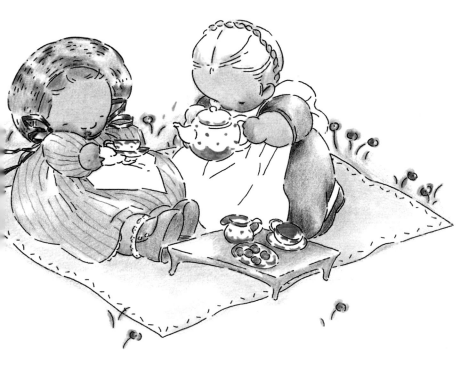

Sharing a story.
(How long should it brew?)

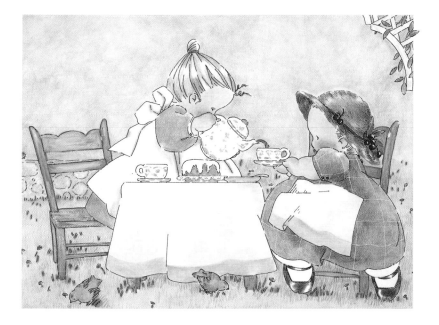

*Two little ladies,
most polite...*

...ever so talented,
such a delight!

Listening sincerely,
offering advice...

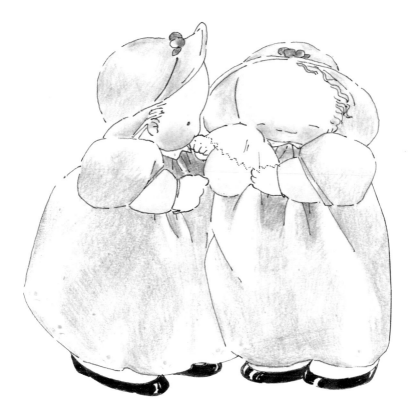

*...helping each other
without thinking twice...*

...making up mischief
(nothing too bold)...

...doing good deeds
(hearts of gold!)

Two little ladies,
not too prim...

...fun on an impulse,
plans on a whim...

...ever capricious,
as close as could be...

...two little ladies,
you and me!